A SHORT BIOGRAPHY OF GEORGIA O'KEEFFE

A SHORT BIOGRAPHY OF
Georgia O'Keeffe

Kira Randolph

BENNA BOOKS
A Boutique Press for Artists & Writers

Carlisle, Massachusetts

A Short Biography of Georgia O'Keeffe

Series Editor: Susan DeLand
Written by: Kira Randolph

To Clay

Copyright © 2017 Applewood Books, Inc.

978-1-944038-16-8

Front cover: Alfred Stieglitz (American, 1864–1946)
Georgia O'Keeffe, 1918, Platinum print
The Art Institute of Chicago / Art Resource, NY
Back cover: Georgia O'Keeffe (American, 1887–1986)
Road to Pedernal, 1941, Georgia O'Keeffe, 2006.05.170
Gift of the Georgia O'Keeffe Foundation
© Georgia O'Keeffe Museum
Georgia O'Keeffe Museum, Santa Fe / Art Resource, NY
© 2017 Georgia O'Keeffe Museum / Artists Rights Society (ARS), New York

Published by Benna Books
an imprint of Applewood Books
Carlisle, Massachusetts 01741

To request a free copy of our current catalog
featuring our best-selling books, write to:
Applewood Books
P.O. Box 27
Carlisle, MA 01741
Or visit us on the web at: www.awb.com

10 9 8 7 6 5 4 3 2 1
MANUFACTURED IN THE UNITED STATES OF AMERICA

GEORGIA TOTTO O'KEEFFE WAS A PAINTER who took an independent and visionary road that led to her recognition as the mother of American Modernism. She was born on November 15, 1887, on a 640-acre farm near Sun Prairie, Wisconsin. Georgia's Papa, "Frank" Calyxtus O'Keeffe, and Ma, Ida Totto, knew each other from neighboring farms, and this simple, healthy life was the foundation for their marriage. The Catholic O'Keeffe family immigrated to Sun Prairie from Ireland in 1848. Arriving a decade later, the Episcopalian Totto family

was of Hungarian heritage and distant nobility.

Prior to becoming a farmer's wife, Ida aspired to becoming a doctor but relinquished that dream for family life.

Once married, Frank and Ida moved onto the Totto homestead. Georgia was the eldest girl in the family of seven children and named after her maternal grandfather, George Totto. Georgia had one older brother, the firstborn Francis Calyxtus, and one younger brother, Alexius Wyckoff. She also had four sisters: Ida Ten Eyck, born two years after Georgia, followed by Anita Natalie, Catherine Blanche, and Claudia Ruth.

Though her early adulthood was marked by frequent relocations to pursue teaching courses and opportunities, Georgia's youth in Sun Prairie was stable. Childhood on the farm played an important role in O'Keeffe's art throughout her life. Wherever she was, nature was her greatest inspiration. Art and music were a regular part of the family's time together. The children's grandmothers, Isabella Wyckoff and Mary O'Keeffe, both painted, and Ida played the piano each night.

As a child, Georgia also learned to play piano, as well as the violin.

Ida arranged for her eldest daughter, along with young Ida and Anita, to receive art instruction at home and, later, in town. This early and formal introduction to art shaped Georgia's vision of herself, and at age twelve she announced her artistic ambitions to a friend. In her autobiography, Georgia recalls a pleasant childhood but disliked the local school she attended from the age of five until she was thirteen. She found the school dull. Art was most interesting, but she could not bear when teachers corrected her drawings. Georgia, Ida, and Catherine all grew up to become artists. The sisters enjoyed a friendship throughout their lives that extended into warm, heartfelt letters in adulthood. Shared artistic aspirations were a source of rivalry, however, causing frequent, sometimes extended rifts.

Georgia attended the Sacred Heart Academy convent school in Madison,

Not knowing what it meant to be an artist, Georgia said she aspired to be "portraitist."

Wisconsin, as a boarding student in 1901. Her parents paid a twenty-dollar fee for drawing lessons from Sister Angelique. When the O'Keeffe family moved to Williamsburg, Virginia, in search of a better life, Georgia stayed with her aunt "Lola," Leonore Totto, to attend Madison High School. The following year she joined her family and in the fall resumed her studies at the Chatham Episcopal Institute, Chatham, Virginia, where she was a member of Alpha Kappa Delta sorority.

Georgia entered the world with an aesthetic all her own which manifested in all aspects of her life: a minimalism in art, dress, and possessions. At Chatham classmates noticed the individualist fashion sense that became her trademark. As a youngster, Georgia had learned to sew and was able to create her own clothes in whatever style she chose. In a school where young ladies wore dresses adorned with ruffles and bows, with ribbons in their hair, Georgia wore

The most memorable art criticism came from a drawing deemed too small; she vowed never to produce an artwork of that scale again.

a loose, plain suit. Nonetheless, her confidence and self-assurance intrigued her classmates, and they grew fond of her distinctness. She was art editor of the yearbook, and this rhyme was listed under her photograph: "O is for O'Keeffe; an artist divine / Her paintings are perfect and her drawings are fine."

Georgia continued her studies at the Art Institute of Chicago in 1905. Unfortunately, contracting typhoid fever during the summertime following her first year prevented her return. In 1907, recuperated, she began to study at the Art Students League in New York, under the instruction of painter William Merritt Chase. Her 1908 still life *Untitled Dead Rabbit with Copper Pot* earned her the one full-ride scholarship awarded to study at the prestigious Amitola art colony in Lake George, New York, that summer. Amitola, built in 1905 and later called Wakonda Lodge, was Katrina and Spencer Trask's visionary place for artists to learn and work.

Her first excursion to photographer and gallerist Alfred Stieglitz's Gallery 291 to see watercolors by Auguste Rodin was with a group of League classmates.

When she returned home from Amitola, it was apparent from the deteriorated financial state of her family that she would not return to the League. Instead of resuming studies there, Georgia returned to Chicago, pursuing work as a freelance commercial artist while living with her uncle Charles and aunt Georgiana Ollie, as she did when she attended the institute some years earlier. When she later spoke of this first break from painting, she claimed it was in response to working in the tradition of Realism and her frustration with being unable to differentiate her works from those of other artists. Illness caused another return home to her family, this time with the measles, which temporarily affected her vision and made the detailed work of illustrating impossible.

During this time, she was one of the alleged illustrators of the Old Dutch Cleanser logo, depicting a woman chasing dirt.

Ida O'Keeffe contracted consumption, for which there was no cure. Believing a warmer climate might improve her condition, she and her younger children moved from Williamsburg to Charlottes-

ville, Virginia, leaving Frank to tend to his concrete block production business. He joined the family three years later, but Ida died shortly thereafter. That spring, Georgia's former principal and art instructor at Chatham, Elizabeth May Willis, gave Georgia her first teaching opportunity, which guided her return to painting. The same year, the direction of Georgia O'Keeffe's artistic career was forever changed with her introduction to the writings of Arthur Wesley Dow at the University of Virginia, whose influential text *Composition* paved the way for her explorations into Abstractionism.

The six-week stint as an art teacher proved she could create a life for herself as an educator and an artist.

Encouraged by her sisters Ida and Anita, Georgia enjoyed the summer art classes offered at the University of Virginia by Alon Bement, who taught Dow's methodologies. Dow embraced the technique of eighteenth-century Japanese artist Katsushika Hokusai and felt the artist's perception should be expressed through harmonious use of line, color, and *noton* (the Japanese use of dark

and light). The influence of his exercise instructing art students to reduce the landscape to main outlines by omitting all detail is demonstrated in Georgia's watercolors from this period. O'Keeffe excelled at Bement's most advanced class and returned the following three summers as his assistant. They read and discussed influential art history discourse about Cubism, Post-Impressionism, and Wassily Kandinsky's seminal book, *On the Spiritual in Art*.

In 1914, Georgia O'Keeffe enrolled in the bachelor of science program in fine arts education at the Teachers College at Columbia University in Manhattan. It was an exciting time to be back in New York City. Georgia befriended extroverted classmate Anita Pollitzer, who was studying photography and was also a fiend for so-called "New Art." Alfred Stieglitz, pictorial photographer, and Edward Steichen, photographer and painter, opened a Photo-Secession gallery in Steichen's studio at 291 Fifth Avenue

Because of the Armory Show of 1913, New York City was firmly at the center of the art world.

in 1905. Their exhibitions were the first and most influential in bringing modern art to America. Georgia and Anita regularly visited 291, where they saw the jointly billed Georges Braque and Pablo Picasso exhibition.

Coinciding with the introduction of modern art, independent women were becoming political. Paintings by Mary Cassatt were exhibited at the Armory Show alongside her male counterparts' works. She and her influential female friends were insistent that their place in the world be recognized. Pollitzer became active in the National Women's Party as a suffragette, and she involved O'Keeffe.

In the fall, rather than joining Anita for a second year at the Teachers College, Georgia accepted a job at Columbia College in South Carolina. This was a pragmatic decision Georgia carefully considered. Her teaching schedule allowed time for individual art explorations without the distractions of her New York

In February 1926, O'Keeffe accepted Pollitzer's invitation and addressed the National Women's Party in a speech that promoted the importance of self-reliance.

life. Deciding that her education had been of little use except for introducing tools of the artist's trade, she set out to make a series of charcoal drawings that were purely hers, not derivative of any art movements and definitely not to please anyone, as her other works had been.

It occurred to me, I had ideas of my own I had never put down before, as I had never seen things like them.

She rolled these drawings into a tube and mailed them from South Carolina to Anita Pollitzer in New York City for her feedback. Unbeknownst to Georgia, Anita took these drawings to Stieglitz. During the friends' correspondence, Georgia had confided that, should she ever make anything that satisfied her, she would solicit Stieglitz's opinion. Stieglitz was absorbed by the drawings and instructed Anita to tell Georgia of their

Based on what he passionately exhibited in his gallery, Stieglitz's validation was worth more than that of anyone else.

fine quality. His rumored response to Anita was: "At last! A woman on paper!" These first drawings launched a love story and a thirty-year correspondence between Georgia and Alfred.

Back at Teachers College, O'Keeffe was surprised when a student asked if she was "Virginia" O'Keeffe, currently showing in a group exhibition at Gallery 291. Although Stieglitz had not formally met Georgia O'Keeffe, he believed so strongly in her drawings that he displayed them without her knowledge or permission and even under an incorrect name. One can imagine O'Keeffe's delight—and alarm—at seeing her private drawings on public display. Alfred Stieglitz was raised in New York and educated in Germany, and he had a successful career promoting photography, French artists, and American modern art. His Gallery 291 had been open for more than a decade. At the time that O'Keeffe and Stieglitz emitted sparks over his hijacking of her drawings, he had been married

to his wife, Emmeline, for twenty-three years and they had an eighteen-year-old daughter, Katherine.

Georgia O'Keeffe was instated as West Texas Normal College head of the art department in Canyon, Texas, in the autumn of 1916. The *Amarillo Daily News* inflated her qualifications, claiming she held a fine arts degree. Her childhood on the farm gave Georgia a lifelong affinity for open spaces, which she also relished in Texas, deciding it was her spiritual home. Georgia once again infused color into her art. She painted over seventy watercolors, including nude studies of her own body similar in style to those by Rodin, which she had seen at Gallery 291 in 1908.

Stieglitz staged Georgia's first solo show in April 1917, his last exhibition at 291. The United States entered World War I three days after the exhibition opened. Hearing that the 291 building was to be demolished, O'Keeffe was determined to see her first exhibition. She withdrew her entire savings of $200 and impulsively

traveled from Canyon to New York, arriving unannounced. Georgia's timing was off and she arrived to discover that the show had ended and the artwork was removed. Yet Stieglitz rehung it for her. Alfred and Georgia connected on a deep level. The letters that followed O'Keeffe's return to Texas were frequent and intense, sometimes more than one a day. Georgia contracted a severe respiratory infection, and increasing concern led Stieglitz to send young photographer Paul Strand, whom Stieglitz represented at his gallery, to persuade her to recuperate in New York City. Once she was there and recovered, Stieglitz offered O'Keeffe a gift that launched her career: one year in the city with accommodation and board so that she could focus solely on her art.

Georgia O'Keeffe's parents had died within two years of each other, her mother in 1916 and father in 1918, leaving her without a family home. Very much alone in the world, O'Keeffe and Stieglitz became more than just lovers; they were

Alfred and Emmeline Obermeyer Stieglitz separated in 1918 and finalized their divorce in 1924.

intense supporters of each other, both personally and professionally. Each understood what it meant to be committed to one's art first. Stieglitz was well connected, and the social circle of his gallery and its patrons embraced O'Keeffe. She met artists Miguel Covarrubias and Rosa Rolanda and writer Jean Toomer, along with arts patron, critic, and socialite Mabel Dodge Luhan. Additionally, O'Keeffe was active in the Stieglitz circle of artists, which included Arthur Dove, Marsden Hartley, John Marin, and Paul Strand.

Stieglitz was demanding of his lover/protégé. He was a master promoter of her work yet opinionated; he insisted she use oil paints. While O'Keeffe began her painting practice in New York City, Stieglitz commenced his great modernist project, composite photographic portraiture of Georgia, which spanned many decades. Stieglitz owned four galleries during his lifetime, but the biggest gap in proprietorship was the eight years between the closing of Gallery 291 and the opening of

Anderson Galleries. Filled with the passion of their early love affair and alleviated from gallery operations, Stieglitz and O'Keeffe became partners in creating a body of photographs featuring O'Keeffe.

In 1921, Stieglitz staged his first solo exhibition in eight years, featuring portraits of O'Keeffe. Her sensual poses and glimpses of her artwork in the portraits created allure and intrigue. O'Keeffe's artwork had not been on public view since 1917, which created intense curiosity about the woman who was both creator and muse. According to one critic, this exhibition transformed O'Keeffe into an overnight newspaper personality. While Stieglitz was a critical factor in the early promotion of O'Keeffe's own work, he was also responsible for eroticized interpretations of her paintings. His essay "Women in Art" expressed his belief that women experience the world through the womb. The trajectory of O'Keeffe's most prolific period, the 1920s, coincided with the popularity of psychoanalysis and Freudian

Between 1917 and 1937 Stieglitz took 329 photographs of O'Keeffe, making her possibly the most-photographed woman of the twentieth century.

interpretations of art. In 1923, over one hundred of O'Keeffe's works were exhibited at the Anderson Galleries, the same location where Stieglitz exhibited their revealing portraits of her. The following year, Stieglitz simultaneously exhibited O'Keeffe's drawings, oils, pastels, and watercolors alongside his photographs, correlating the two.

While the salacious reviews created excessive publicity, increasingly O'Keeffe moved toward recognizable forms and shapes. The first of O'Keeffe's large-scale botanical paintings was *Petunia No. 2,* 1924. Her reasoning for enlarging the flowers was to attract the attention of busy New Yorkers. However, her denial that she was painting anything other than a petunia or an apple further exacerbated speculation.

> *I made you take time to look at*
> *what I saw and when you took*
> *time to really notice my flower,*
> *you hung all your own associations*

*with flowers on my flower and you
write about my flower as if I think
and see what you think and see of
the flower—and I don't.*

From 1918 to 1934, O'Keeffe and Stieglitz traveled from Manhattan to Lake George, where they spent several months on his family's estate in the Adirondack region. Georgia and Alfred married in 1924; it was her only marriage and spanned twenty-two years. The ceremony was a civil service by a justice of the peace, conducted with little celebration. O'Keeffe did not have strong feelings about marriage and chose to keep her surname. By then O'Keeffe had achieved notable acclaim as a painter of modern art. She attained financial independence, and the sales price for several paintings broke records. The union between O'Keeffe and Stieglitz went forward in spite of objections from his daughter, Kitty, who had protested their relationship from the time of her par-

Blooms inspired by fields of red poppies in Lake George became O'Keeffe's most beloved subject matter.

ents' separation in 1918. Stieglitz mistakenly believed the legitimization of his relationship with O'Keeffe would heal his bond with his daughter. Calamitously, Kitty's condition only worsened.

Witnessing the rising of the Shelton skyscraper on Lexington Avenue, O'Keeffe turned her attention toward documenting the city. She was told this was impossible, something even the male artists couldn't accomplish. Her cityscapes triumphed over expectation. She was the only woman represented in the exhibition, *Paintings by 19 Living Americans* at the Museum of Modern Art in 1929. Among the five paintings included was her magnificent *Radiator Building,* 1927.

Alongside her successes, O'Keeffe experienced personal and professional hardships, particularly from the late twenties into the early thirties. Her relationship with Stieglitz was without the baby she craved, leaving a sense of emptiness. In 1926 she underwent sur-

gery for suspected breast cancer that involved the removal of a benign tumor. In 1928, sixty-four-year-old Stieglitz and his twenty-three-year-old gallery assistant, Dorothy Norman, began an affair that lasted until his death. Though O'Keeffe and Stieglitz's marriage remained intact, the infidelity broke into their protected sphere of trust and respect. In 1932, overwhelmed by technical difficulties related to time and the painting surface, O'Keeffe abandoned a competitive Radio City Music Hall mural commission. O'Keeffe suffered a mental breakdown in 1933, diagnosed as psychoneurosis, which left her exhausted and listless following a six-week stay at the hospital. Her thirteen-month rehabilitation marked her second break from painting.

Years before, in 1917, Georgia and her sister Claudia stopped in New Mexico while returning to Texas by train from Colorado. O'Keeffe returned to New Mexico in the summer of 1929 at age forty-two, after discovering her husband's

affair. That year, Georgia and her traveling companion, Rebecca "Beck" Strand, were guests of Mabel Dodge Luhan in Taos, New Mexico. Luhan maintained a vibrant twelve-acre artist's colony with an eighteen-room main house and five guesthouses for visiting artists. The southwest was a delight for the senses, exposing them to a plethora of inspiring stimuli. Beck and Georgia stayed at the pink house occupied by the British writer D. H. Lawrence the previous summer.

Because of recent droughts, there were few wildflowers during O'Keeffe's first extended summer in New Mexico, so instead of flowers she collected bones, bleached white from the sun. These skulls and thigh and pelvic bones became the emphasis of still life paintings she made for over twenty-five years. She later combined bones and flowers on the same canvas, as in the 1936 *Summer Days,* purchased by Calvin Klein and donated to the Whitney Museum of American Art. Stieglitz never traveled to

New Mexico, and the two saw considerably less of each other from 1932 to 1935. Driving across the northern New Mexican landscape inspired O'Keeffe to paint objects from Pueblo Indian visual culture, crosses of the *Penitente,* the vast mesas, and the unending sky.

O'Keeffe spent her first summer at Ghost Ranch, a former dude ranch, in 1934 and bought the property in 1940. In early 1939 she accepted a commission from Dole Pineapple Company to create two paintings for a print advertising campaign that included a three-month accommodation in Hawaii to study the islands for source material. After that travel and stays in New York with Stieglitz, each summer between 1940 and 1946 O'Keeffe returned to New Mexico. She bought her second home, a Spanish Colonial–era compound located in the village of Abiquiu, in 1945.

During her lifetime, O'Keeffe strategically sold and donated her artwork to major collections, ensuring her visibility

After her first summer in New Mexico, O'Keeffe shipped a barrel of bones back to New York City to paint.

across the United States. When her husband, Alfred Stieglitz, died in 1946, she approached the placement of his photography in the same careful way that he had promoted and managed her career. O'Keeffe missed the opportunity to say good-bye to her husband, who died at age eighty-two. Before his health began to fail, he was an extreme hypochondriac, making it difficult to gauge the seriousness of his health concerns. She had been aware of his death coming—he had already suffered and recovered from one heart attack. When he died from a stroke, she took his ashes and buried them privately in Lake George, the site of their many summers together.

Following the death of Stieglitz, Georgia left Abiquiu and stayed in New York City for three years settling his estate before making New Mexico her permanent residence at age fifty-nine. The abandoned hacienda in Abiquiu needed restoration, and during the time O'Keeffe was in New York City her friend Maria Chabot oversaw the

work. Due to temperature variations between Ghost Ranch and Abiquiu, O'Keeffe alternated her living arrangements.

Her two homes, like her paintings, were some of her greatest works of art, exhibiting her distinctive sense of style and nuance. Georgia decorated sparsely with her favorite things: top-quality stereo equipment; her collections of rocks and bones; and notable gifts, such as a Noguchi paper lamp and an Eames lounge chair and ottoman. Cookbooks in her library indicate an interest in a healthy diet. She maintained this by eating a daily lunchtime salad of organic vegetables from her garden. Her favorite midmorning snack was a blended drink of yogurt and fruit, akin to what we now call a smoothie, before it gained mainstream familiarity. She shared her homes with a series of six Chow dogs she owned in pairs for company and safety.

The American Southwest became O'Keeffe's signature subject matter. She had purchased her first vehicle in 1929 and learned how to drive. She created a

The winter was milder in Abiquiu and she had a garden there, but traveled each summer to be at Ghost Ranch.

mobile studio out of a Model A Ford by stripping out the backseat. By swiveling around the driver's seat, she utilized it as an easel. The shelter of the vehicle meant she could paint the landscape in the middle of the day, protected from the desert sun. Another favorite vista to paint was Cerro Pedernal, a mesa she could see from her Ghost Ranch patio. Though each home had a studio, she painted the largest canvas of her career, one of the cloud series, using the entire twenty-four-foot width of her Ghost Ranch garage.

She regularly went on painting and camping trips to places such as the White Place, Plaza Blanca, and the Black Place.

> *I found I could say things with color and shapes that I couldn't say any other way...things I had no words for.*

In 1958 Georgia traveled to Mexico, reconnecting with Frida Kahlo and Diego Rivera, whom she previously met in New York City. O'Keeffe ventured on her first major international trip in

1959, spending three and a half months sightseeing in Asia, India, Italy, and the Middle East. Views from airplanes of the land below inspired her final series of paintings, aerial views of rivers and clouds. In 1971, O'Keeffe started losing her central vision, leading to the third break from painting in 1972. She had loyal help in Abiquiu from three generations of the Lopez family. They helped her in her garden, with cooking and paperwork, keeping up her grounds, and when she lost her vision. Her last unassisted painting was in 1972, but she continued to work with assistance until 1977.

In 1973, sculptor Juan Hamilton traveled to Ghost Ranch seeking employment; O'Keeffe asked him to pack a painting for her. A thirteen-year friendship began as he became O'Keeffe's closest friend and assistant, taking her on walks, traveling with her, and sparking her interest in making clay pots, which she could accomplish with limited vi-

Limited by macular degeneration, O'Keeffe completed her last unassisted painting in 1972.

sion. O'Keeffe continued dividing her time between Ghost Ranch and Abiquiu until 1984, when, at ninety-seven years old, she moved to Santa Fe to be closer to medical facilities. O'Keeffe spent her final two years living with Juan and his wife before dying on March 6, 1989, in St. Vincent's Hospital. Her ashes were spread from the top of Pedernal, over the landscape she declared the most beautiful in the world.

Georgia O'Keeffe has received an astonishing number of accolades. In 1946 she became the first woman to receive her own solo MoMA exhibition. In 1962 she was elected to the American Academy of Arts and Letters, filling the seat vacated by the death of poet e.e. cummings. In 1970 the Whitney Museum of American Art hosted her retrospective. By 1977 O'Keeffe was bestowed with the United States Medal of Freedom, the highest honor granted to a civilian from the government, and in 1987 received the National Medal of the Arts.

The Georgia O'Keeffe Museum in Santa Fe, New Mexico, opened in July 1997— the only museum in the United States devoted to a single woman artist. In 2009, the United States Postal Service released *Red Poppy,* 1927, as a thirty-two-cent stamp in a limited edition of 156 million, flooding the mail with her now best-known floral painting. In the November 2014 Sotheby's American Art auction, sale of Georgia O'Keeffe's 1932 *Jimson Weed/ White Flower I* exceeded the upper estimate of $15 million, selling for the record-breaking $44.4 million hammer price.

The Georgia O'Keeffe catalogue raisonné records over two thousand paintings, drawings, sculptures, and ceramic pots. To date, her work is held in over one hundred public collections internationally. Georgia O'Keeffe's impact on the world as one of the most significant and recognizable artists of the twentieth century can be seen in her abstractions, landscapes, and botanic and bone paintings.

Georgia O'Keeffe and Alfred Stieglitz shared the burn of creativity but not the environment that allowed each to flourish. The cinder colors of the city fed his photography. Ultimately, she needed the light, expanse, and earth tones of the desert. Her canvases could not be contained in the city. Her artist's eye brings us the endlessness of earth and sky, yet also draws us into the interior of a flower as if captured by its petals.